TIMKEN MUSEUM OF ART

Acquisitions

1995–2005

The Putnam Foundation
San Diego, California

This publication is a supplement to *Timken Museum of Art, European Works of Art, American Paintings, and Russian Icons in the Putnam Foundation Collection* (ISBN 1-879067-01-3).

ISBN 1-879067-09-9

Hal Fischer, general editor
Fronia W. Simpson, editor

Catalogue designed by Gordon Chun Design
Printed in Hong Kong through Global Interprint,
Santa Rosa, California

Cover:
Sir Anthony van Dyck
Mary Villiers, Lady Herbert of Shurland (detail)

Timken Museum of Art
1500 El Prado, Balboa Park
San Diego, CA 92101
619-239-5548
www.timkenmuseum.org

STAFF OF THE TIMKEN MUSEUM OF ART

John A. Petersen, *Executive Director*
Laurie Hawkins, *Deputy Director*
Hal Fischer, *Director of Exhibitions and Publications*
Anne Hoehn, *Curator of Education*
Janet Klauber, *Director of Development*
James Petersen, *Administrator*
Tara Murphy, *Development and Administrative Coordinator*
Gay Nay, *Assistant to the Director*

Contents

Dedication

This publication is dedicated to Nancy Ames Petersen, who assumed the directorship of the Timken in 1979. Over a seventeen-year period, until her retirement in 1996, Nancy guided the museum through a period of significant growth and accomplishment. Her eye for quality and her negotiating skills enabled the Putnam Foundation to acquire such great works of art as Italian masterworks by Bartolomeo Veneto, Guercino, and Luca Carlevarijs and American masterpieces by John Singleton Copley and Fitz Hugh Lane. Nancy continued the tradition established by Walter Ames, the Timken's founding director, of drawing upon the best and brightest art historians for counsel in the areas of acquisition, collections management, and programming. She established productive relationships with curators at leading institutions, including the National Gallery of Art and the Metropolitan Museum of Art, as well as independent specialists in both the United States and Europe. Many of these individuals remain trusted advisors, unstintingly generous with their advice and insights.

In the early 1980s Nancy set in motion initiatives that would dramatically change the museum's profile, enabling us to serve the San Diego community more fully and, at the same time, to bring national and international recognition to the Timken. Education and fundraising programs were initiated, and an ambitious exhibition program, accompanied by scholarly catalogues, inaugurated. The museum we are today—a vital institution working to bring quality to every aspect of our activities—is the realization of Nancy's vision. We are grateful to Nancy for her years of dedicated service and proud to strive for the high standards she set for us.

Putnam Foundation Acquisition Fund Donors 1995–2005

Mary and Dallas Clark

Dr. Charles C. and Sue K. Edwards

Walter Fitch III

The Fredman Family

Mary Ann and Arnold Ginnow

Connie K. Golden

Ingrid B. Hibben Charitable Fund

Karen and Robert A. Hoehn

Sally S. Jones

Jane Bowen Kirkeby

The Legler Benbough Foundation

Josephine R. MacConnell

Burl and Bill Mackenzie

Marjorie H. Mitchell

Gay Michal Nay

Pamela F. and Philip R. Palisoul

J. Douglas and Marian R. Pardee Foundation

Lois S. Roon

Donna Knox Sefton

J. W. Sefton Foundation

Judith and Stephen W. Smith

Diana Woodward Stephens

Timken Foundation

Friends of the Timken

Amparo Valenzuela

Frances Hamilton White Donor Advised Fund at the Rancho Santa Fe Foundation

Anonymous
Margaret and F. P. Crowell
Dr. Albert and Sharon Cutri
Charles H. Cutter
Betty De Bakcsy
Dr. Charles C. and Sue K. Edwards
Drs. Edward and Ruth Evans
Madeline L. Goldberg
Alice Bourke Hayes, PhD
Angel and Fred Kleinbub
Sharon and Joel Labovitz
Jesse Osuna
Janette and Gordon Pledger
Ellen and Roger Revelle
Kate and George W. Rowe
Dr. Seuss Fund at The San Diego Foundation
Mr. and Mrs. John W. Thiele
Gilda and Victor Vilaplana
Ginger and Robert Wallace
Therese Truitt Whitcomb
Lisa and Richard Zinne

Gay and Robert Ames
Dr. and Mrs. Arthur L. Austin
Emily T. Bagnall
Mr. and Mrs. Bruce H. Bradbeer
Esther J. Burnham
James E. Bush and Isabel Negrete
Mr. and Mrs. Jack. E Cater
Dolores Clark
Ann and Roger Craig
Mrs. James E. DeLano
Jeane Erley
Margaret Eske
Willis and Jane Fletcher Fund
Andrew Forbis
Jeanne L. Frost
Martha and George Gafford
Alison and George Gildred
Connie and John Hucko
Marie K. and Michael F. Huff
Ann and Charlie Jones
Maurice Kawashima
Colleen Kerr
Mr. and Mrs. Thomas Ladner
Donald W. Lloyd
Dr. Rose E. Merino
Margery A. Mico
Miriam and Kevin Munnelly
Ernestine C. and John C. Peak
Mary Beth and John Petersen
Nancy Ames Petersen
Mary Lou Peterson
Dr. Richard Wunder
Barbara J. and Robert J. Ritz
Dr. and Mrs. R. Edward Sanchez
Admiral and Mrs. U.S. Grant Sharp
Deborah C. Streett-Idell and James B. Idell
Janet K. Sutter
Mr. and Mrs. Ubaldo Trevino
Dixie and Ken Unruh
Elisabeth and Donald Winn
Ann L. Zahner

Introduction

No other element of a museum's mission or responsibilities creates as much excitement among the board, staff, volunteers, and community as an important acquisition. A new acquisition demonstrates a commitment to the continued growth and refinement of the museum's holdings.

Since 1996 the Timken Museum of Art has been fortunate to have added five important masterworks to its permanent collection of European and American paintings. Much time and effort go into each acquisition, and many individuals are involved in the process. Issues such as the quality and significance of the work, and its attribution, provenance, condition, and asking price must all be addressed before it is added to the permanent collection. Over the museum's first forty years, the directors of the Putnam Foundation and the Acquisitions Committee have relied on the expertise of many prominent academic art historians, museum professionals, and conservators when considering the purchase of a new painting. These experts have also given freely of their advice in setting a course for future additions to the collections. Artists, periods, styles, and schools that would strengthen the collection have been identified, and consensus has been reached with respect to the museum's needs. Over the last decade we have been able to fulfill a number of our goals.

In 1997 the Timken mounted an important focus exhibition entitled *Art and Devotion in Siena after 1350*. Among the works lent for this show was a magnificent altarpiece by Niccolò di Buonaccorso entitled *Madonna and Child*, which at the time was in the Heinz Kisters collection in Switzerland. Buonaccorso is known primarily for his small-scale altarpieces used for private devotion, and this fourteenth-century masterpiece is one of only a handful of large-scale altarpieces by the artist known to survive.

Laurence Kanter, Curator of the Robert Lehman Collection at the Metropolitan Museum of Art, and a longtime adviser to the Timken, stated that the painting had been for sale some years earlier and that the owner might be willing to part with the painting. Dr. Kanter added that the acquisition of this rare piece would further strengthen the Italian collection and, in his opinion, would give the Timken Museum of Art one of the finest collections of fourteenth-century panel paintings on the West Coast.

With the help of Federico Frediani from the Legale Associato, the museum was able to contact Professor Federico Zeri, a noted specialist in early Italian painting, as well as Professor Miklós Boskovits and Dottoressa Chiodo of the German Institute for the Study of Art History, Florence. Professor Boskovits had identified the work as the central fragment from the signed altarpiece in Santa Margherita at Costalpino, and Professor Zeri, too, was very familiar with the altarpiece's history and provenance. Conservator David Bull conducted a thorough examination of the panel's condition and found it to be of superior quality for a work from this period. After several months of negotiation, Jane Bowen Kirkeby, chair of the museum's Acquisitions Committee, reported to the board that the Kisters family had agreed to sell the piece to the Putnam

Foundation. Through the generosity of Mr. Walter Fitch III, Mrs. Richard C. Mitchell, and the Timken Foundation, the purchase of this masterpiece was completed in 1998.

In 2000 the Acquisitions Committee turned its attention to the American collection. Michael Quick, former Curator of American Art at the Los Angeles County Museum of Art, was retained to help the committee in its search for an important still-life painting from the Philadelphia school. This represented an area that many scholars of American art had identified as a missing component of the Putnam Foundation's permanent holdings. Quick located two important works for the committee to consider: John F. Peto's *In the Library* and Raphaelle Peale's *Cutlet and Vegetables*.

The museum contacted John Wilmerding, then professor of American art at Princeton University, and a noted scholar of American art and an authority on the work of Peto, and Alexander Nemerov, then professor of American art at Stanford University, and author of *The Body of Raphaelle Peale*, a scholarly book that explores Peale's still-life paintings. Additionally, longtime advisers Grant Holcomb III, Director of the Memorial Gallery in Rochester, New York, and Carrie Rebora Barratt, Associate Curator of American Paintings and Sculpture at the Metropolitan Museum of Art, were also consulted on the merits of the works being considered. Everyone agreed that either of the paintings would be a strong addition to the collection. Wilmerding, who had also advised the museum on the acquisition of Eastman Johnson's cranberry harvest masterwork in 1972, called the Peto "a fabulous painting, a perfect work for the Timken's collection." He also praised the Peale and suggested that we try to acquire both works. The Acquisitions Committee and the foundation's directors agreed with Wilmerding, and a campaign to raise the needed funds was undertaken. With lead gifts coming from the Legler Benbough Foundation, the J. W. Sefton Foundation, the J. Douglas and Marian R. Pardee Foundation, Sally S. Jones, Milton and Faiya Fredman, and Jane Bowen Kirkeby, as well as additional support from individual members of the Friends of the Timken, the Putnam Foundation was once again successful in achieving its goal.

In 2003, with the museum's fortieth anniversary two years away, the directors of the Putnam Foundation set the goal of adding a painting to the collection as part of the anniversary celebration. Through an act of unexpected generosity, we have been fortunate enough to add two works during our anniversary year. In September 2005 a beautiful 1867 landscape of the Roman countryside by the American artist Thomas Moran was donated by Diana Woodward Stephens in memory of her father, Benjamin Woodward, and her husband, William T. Stephens Jr. The painting had been purchased directly from the artist by Diana Stephens's great-grandfather. It is a wonderful addition to the American room, a beautiful complement to the Putnam Foundation's works by George Inness and Albert Bierstadt. We are very grateful to Diana Stephens for this most generous gift.

The second acquisition made this year is the striking portrait of Mary Villiers by the renowned Flemish artist Sir Anthony van Dyck. This masterpiece was brought to our attention by David Bull. A royal commission of Charles I, *Mary Villiers, Lady Herbert of Shurland* is the first painting to be added to our gallery of Dutch and Flemish paintings since 1970.

The acquisition of this painting fulfilled a long-standing desire on the museum's part, one that was heartily endorsed by our expert advisers, to add a portrait by Van Dyck to our holdings. Several times over the past two years we had attempted to do so, only to lose out to other museums. However, our patience and determination won out, and we have added another great work by one of the most respected artists to the permanent collection. With the addition of this beautiful portrait, the museum can now show important works by the four leading Dutch and Flemish portrait painters of the seventeenth century: Rembrandt, Rubens, Hals, and Van Dyck.

Walter Liedtke, Curator, Department of European Painting, and Arthur Wheelock, Curator of Northern Baroque Painting at the National Gallery of Art, Washington, and others unanimously agree that this purchase represents another strong addition to the Putnam Foundation Collection. Once again, members of the community who understand and appreciate the importance of the arts to our lives have come forward to make certain that the Putnam Foundation Collection continues to grow in size and stature. We are grateful to them for their major support of this stellar acquisition.

Since the inception of the Putnam Foundation, the directors have relied on the counsel of experts to guide the foundation in its pursuit of acquisitions. We are particularly indebted to our many colleagues and advisers who have been so generous with their opinions and expertise. In addition to those I have mentioned in the context of specific acquisitions made over the past decade, I would like to extend my appreciation to the following for their support and counsel: Everett Fahy, Derrick Cartwright, Malcolm Warner, and Theodore E. Stebbins Jr.

We are also indebted to the members of the Putnam Foundation's Acquisitions Committee, who were deeply involved in these deliberations. Committee members who were particularly instrumental during this period include Jane Bowen Kirkeby (chair), Therese Truitt Whitcomb, John Thiele, Charles Cutter, Albert Cutri, Marjorie Mitchell, and Jack Timken. We also extend a special thanks to Jane Bowen Kirkeby for her generous support of this publication.

We also want to thank the individuals who have brought this catalogue supplement to fruition. Hal Fischer, the museum's director of exhibitions and publications, oversaw content development and production of this supplement with the same talent, critical acuity, and attention to detail that he has been bringing to the Timken's projects for the past twenty years. Editor Fronia W. Simpson and the team at Gordon Chun Design continue to ensure that Timken publications are eminently readable and visually appealing. Finally, we are especially thankful to Pia Palladino, Associate Curator, Robert Lehman Collection, Metropolitan Museum of Art; Marc Simpson, Associate Director

and Lecturer, Williams College Graduate Program in the History of Art, and Curator of American Art, Sterling and Francine Clark Art Institute; and Arthur Wheelock, Curator of Northern Baroque Painting at the National Gallery of Art, for illuminating our newest acquisitions with their insightful commentaries.

With the help of our colleagues, the efforts of the directors of the Putnam Foundation, and the members of our Acquisitions Committee, we will continue to strive to add major works of art to this world-renowned collection. I hope you are as excited as I am to see what comes our way next.

JOHN A. PETERSEN
Executive Director

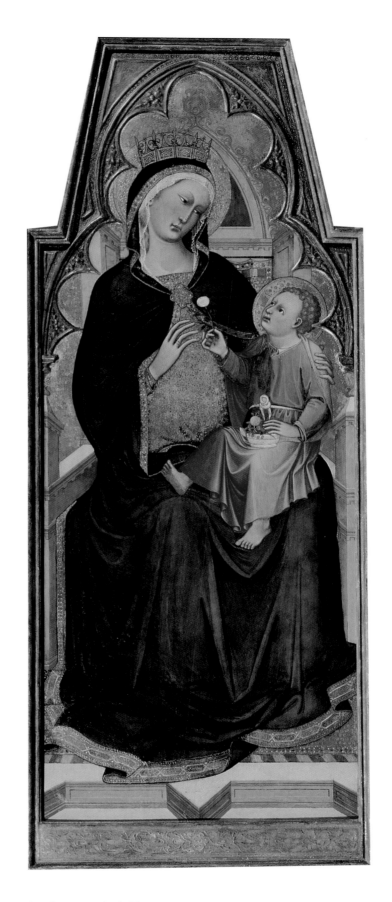

Madonna and Child, 1387

Niccolò di Buonaccorso
(d. 1388)

Niccolò di Buonaccorso is generally regarded as one of the rarest and most engaging Sienese artists of the second half of the fourteenth century. Presumably a son of the Sienese painter Buonaccorso di Pace, Niccolò is first documented in 1372, when he is mentioned as one of the Priori (Priors) for his residential district, the Terzo di Camollia. In 1375 he was elected, together with the painter Bartolo di Fredi, as one of the representatives from the Terzo di Camollia, to supervise the creation of a new election ballot. Subsequent notices, in 1377, 1381, and 1384, record his various other roles in public office. Sometime between 1378 and 1386 Niccolò must have registered in the Sienese painter's guild, for his name appears in the list of artists appended during those years to the 1356 statutes. In 1383 he received a payment from the Opera del Duomo, for a panel of Saint Daniel, a painting as yet unidentified, or lost. These last two notices constitute the only extant documentary reference to Niccolò's activity as a painter, before his premature death in May of 1388.[1]

Firm points of reference for the reconstruction of Niccolò's artistic personality are the signed and dated 1387 altarpiece from the church of Santa Margherita a Costalpino, now in the Timken Museum of Art; a small, signed panel of the Marriage of the Virgin in the National Gallery, London; and a 1385 book cover for the Office of the Biccherna in the Archivio di Stato, Siena, first attributed to the artist by John Pope-Hennessy and Laurence Kanter.[2] The innovative spatial solutions and sophisticated decorative sensibility evinced by these works, and those grouped around them, have led to the suggestion that Niccolò may have received his earliest formation in the 1360s in the workshop of one of Ambrogio Lorenzetti's closest followers, Jacopo di Mino del Pellicciaio. Additional points of reference for Niccolò's development are also discernable, however, in the production of painters trained in the circle of Simone Martini, such as Jacopo di Mino's lesser-known contemporary and possible collaborator, Naddo Ceccarelli, from whom Niccolò appears to have derived the fluid linear rhythms and loosely articulated forms that distinguish his earliest, small-scale paintings. These first influences were superseded, in Niccolò's mature works, by the impact of Bartolo di Fredi's idiom, leading on occasion to a confusion between the two artists.

Madonna and Child, 1387

Tempera and gold on wood, 60 x 23 in. (152.5 x 58.5 cm). Acquisition made possible through contributions from Marjorie H. Mitchell, in memory of Richard C. Mitchell, the Timken Foundation, and Walter Fitch III

Seated on an elaborately carved Gothic throne, which is enhanced by brilliant red finials, the Madonna inclines her head toward the Christ Child and raises her hand to reach for the white rose, symbol of purity, that her son is offering to her from the small basket in his lap. She is wearing the crown of Queen of Heaven (*regina coeli*) and a regal, gilt robe with golden stars under a voluminous blue mantle with elaborately gilt and punched decorative trim at the edges. A delicately painted, sheer white veil frames her face, revealing a few locks of blond hair and softening the austerity of her angular features. The robust child, who looks up knowingly toward his virgin mother, wears a royal purple robe over a pale blue tunic tied at the waist with an elegantly knotted yellow ribbon.

The importance of this impressive, exceptionally well-preserved work was first recognized by Miklós Boskovits in 1980,[3] when he identified it as the missing central panel of a signed and dated altarpiece by Niccolò di Buonaccorso, formerly located in the parish church of Santa Margherita a Costalpino, on the outskirts of Siena. The existence of this altarpiece had been first recorded in the early nineteenth century by the Sienese historian Ettore Romagnoli, who wrote that in 1822 he had discovered in the church of Santa Margherita three panels from a dismembered triptych, showing, respectively, the Madonna and Child, St. Margaret and the Dragon, and an unrecognizable, badly damaged male saint. According to Romagnoli, inscribed on the frame below the Madonna was the partly legible signature, "Nicholaus de Jacobus de Senis . . . XV, " on the basis of which he identified the altarpiece as the only known work, possibly dated 1365, of a mysterious Sienese painter named Niccolò di Giacomo.[4]

Romagnoli's discovery went unnoticed until twenty years later, when his successor, the Sienese historian Gaetano Milanesi, pointed out that the correct reading of the signature below the Santa Margherita a Costalpino Madonna and Child was, in fact, "NICHOLAUS: BONACHURSI.ME. PINXIT. A. DNI. 1387 " (Niccolò di Buonaccorso painted me, in the year of the Lord, 1387). The same author also noted that the second fragment from this altarpiece, with St. Margaret and the Dragon, had originally shown a St. Lawrence, repainted at an unknown date; he made no mention, however, of the third fragment with an unidentified male saint cited by Romagnoli.[5] While Milanesi's findings confirmed the significance of the Costalpino altarpiece as the first known, signed and dated work of Niccolò di Buonaccorso, whose activity had until then been traceable only through documents, they did not have an impact on subsequent research. By the time the next local historian, Francesco Brogi, inventoried the contents of Santa Margherita, in 1862, the Madonna and Child had disappeared, leaving the repainted, largely damaged St. Lawrence, which had in the meantime been removed to the nearby

church of Sant'Andrea a Montecchio, as the only testimony of Niccolò's large-scale production.[6]

The present panel appeared on the art market in 1953, without a signature or date, and was given a tentative attribution to Niccolò's older contemporary Bartolo di Fredi. This identification was unquestioned for thirty years, while the painting remained in the collection of Heinz Kisters, in Kreuzlingen, Switzerland. Boskovits was the first author to point out, aptly, the close stylistic relation of the *Madonna and Child* to the Costalpino St. Lawrence (fig. 1)—restored to its original appearance between 1943 and 1946 and subsequently catalogued as a work of Niccolò by Bernard Berenson—leaving no grounds for doubt that the two images were executed by the same hand, and that they were originally included in the same complex. As Boskovits noted, although the *Madonna* is missing both the signature and the date seen by Milanesi, which were probably included on the destroyed outer frame of the panel, its connection to the St. Lawrence is confirmed by technical as much as stylistic evidence. Both fragments share the same proportions, engaged framing elements, and distinctive *pastiglia* decoration, as well as carpentry construction.[7] Less convincing was Boskovits's proposed association with the Costalpino altarpiece of a predella fragment with the Presentation in the Temple formerly in the Kaulbach Collection, Munich (now Honolulu Academy of Arts, no. 3042), and with another predella panel with the Crucifixion in the Museum of Fine Arts, Budapest (no. 17). The first of these was correctly attributed by Federico Zeri to Bartolo di Fredi or his workshop, while the second is by a follower of Paolo di Giovanni Fei.[8] Nothing is known of the other fragment from the same triptych, showing an unidentified male saint, which was described by Romagnoli but not mentioned in the subsequent literature. Also missing are the pinnacles, which, judging from the remaining evidence of battens on the reverse of the Madonna, must originally have completed the altarpiece. The parallel vertical rays incised in the gold ground around the head of the Virgin, now appearing to emanate mysteriously from the top edge of the panel, suggest that the central pinnacle may have contained a figure of the Blessing Redeemer or of the dove of the Holy Spirit.

Before the recovery of the Costalpino altarpiece, the only firm point of reference for the evaluation of Niccolò's idiom had been the signed triptych with scenes from the Life of the Virgin now divided between the National Gallery, London; the Uffizi, Florence; and the Robert Lehman Collection in the Metropolitan Museum of Art, New York. Around this work, typical of the kind of luxury portable altarpieces produced in Siena throughout the first half of the fourteenth century, successive generations of scholars grouped other small-scale works, such as the triptych in the Timken Museum of Art (1967.2), which are equally characterized by a miniaturist quality of execution and elaborate decorative surface effects. The result was the image of Niccolò as an accomplished but minor master, strongly influenced by the production of Sienese painters formed in the tradition of Ambrogio Lorenzetti and Simone Martini, such as Jacopo di Mino del Pellicciaio and Naddo Ceccarelli.

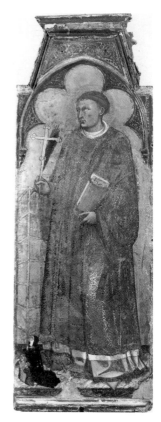

Fig. 1. Niccolò di Buonaccorso, *St. Lawrence.* Pinacoteca Nazionale, Siena

The Timken *Madonna and Child,* and other large-scale works associated with it, mostly datable to the same period, reveal a new point of reference for Niccolò's idiom in the work of Bartolo di Fredi, who held a virtual monopoly over commissions for large-scale altarpieces in Siena throughout the 1380s. Among the works by Bartolo that may have provided the inspiration for the present work is a full-length *Madonna and Child* in the Corsi Collection, Florence, characterized by the same poses and by the motif of the Christ Child offering a rose to the Virgin. Beyond the compositional derivations, Niccolò's debt to Bartolo di Fredi is more specifically discernible in the hardening of the figures' outlines and narrowing of their facial features, which contrast sharply with the loose contours and soft modeling of the forms in the artist's production of the previous decade as represented by the Timken triptych.

If the more incisive formal idiom and stern countenance of the figures point to a shift in orientation toward Bartolo di Fredi's idiom, the spatial sophistication and meticulous attention lavished on decorative details throughout the *Madonna and Child,* as well as in the *St. Lawrence,* nevertheless reflect Niccolò's enduring allegiance to the courtly late Gothic vision that shaped his earliest production. Thus, the simple, modestly built throne of the Virgin in Bartolo's painting is transformed by Niccolò into a fanciful architectural structure that occupies the full height of the picture field and becomes an integral part of the composition. The sharp recession in depth of the arms of the throne and of its solid, geometrically constructed platform provides a clear sense of space and lends a dynamic quality to the image, which contrasts with the essentially static character of Bartolo's prototype. Adding to the visual impact of Niccolò's painting is the artist's typical, extensive use of sgraffito decoration to define ornamental details, such as the pattern of stars on the Virgin's brocade dress, the brilliant effect of which would originally have been heightened by a final coat of translucent colored glazes, now largely worn off the surface.

The size and lavishness of the Timken *Madonna and Child* and of the accompanying panel with St. Lawrence indicate that Niccolò's altarpiece may have been an expensive commission of some importance and prestige, possibly for the high altar of a church or private chapel. That the original location of the triptych was not the small parish church of Santa Margherita is suggested by the repainting of the figure of St. Lawrence into a St. Margaret, presumably to conform with the dedication of the Costalpino church, to which the work may have been transferred from a nearby location. A clue to the altarpiece's provenance may perhaps be found in the detail of the four small figures kneeling in prayer at the feet of St. Lawrence: the painting's probable donor—a nun or widow dressed in a black habit with white wimple—and three children, all of whom appear to be looking up in the direction of the Madonna and Child that originally flanked the panel. Based on the identification of the donor figure as an Augustinian nun, it has been tentatively proposed that the painting may have been transferred to Santa Margherita from the Augustinian convent of Santa Maria Maddalena outside Porta Tufi—not far from Costalpino and Montecchio—after the latter was destroyed in the

sixteenth century.⁹ However, the inclusion of children, perhaps orphans, alongside the donor, raises another possibility: that Niccolò may, instead, have received the commission from someone affiliated with the hospital for the poor that was apparently founded in Costalpino by a certain Donna Agnese, in 1297. The existence of this institution, no longer extant, is recorded by Giuseppe Merlotti in his monumental history of the parishes in the diocese of Siena, completed in 1881, but appears not to be mentioned by other local historians.¹⁰ If Merlotti's reference is accurate, it might be surmised that the Costalpino hospital was an outpost of the more famous Spedale di Monna Agnese in Siena, founded around 1278 by the Sienese noblewoman Agnese di Orlando Malavolti, with the specific function of providing assistance to poor, unwed mothers and their newborns.¹¹ Monna Agnese's hospital, which quickly became one of the major charitable institutions in Siena, attracting donations from the Commune and from private citizens, was run by oblates who followed the Augustinian rule. It is perhaps one of these pious women who is portrayed with her young charges in Niccolò's altarpiece.

P.P.

NOTES

1. For these documents see Pia Palladino, *Art and Devotion in Siena after 1350: Luca di Tommè and Niccolò di Buonaccorso*, exh. cat., Timken Museum of Art (San Diego, 1997), pp. 46–47 (with previous bibliography).

2. Pope-Hennessy and Kanter, *The Robert Lehman Collection: Italian Paintings*, New York and Princeton, 1987, p. 33.

3. Miklós Boskovits, "Su Niccolò di Buonaccorso, Benedetto di Bindo, e la pittura senese del primo Quattrocento," *Paragone*, nos. 359–61 (1980): 4–5, 15 n. 5.

4. Ettore Romagnoli, *Biografia cronologica de bellartisti senesi* (Siena, 1835; reprint, Florence, 1976), 3:295–96.

5. Gaetano Milanesi, *Documenti per la storia dell'arte senese* (Siena, 1854), 1:31–32.

6. Francesco Brogi, *Inventario generale degli oggetti d'arte della provincia di Siena (1862–1865)* (Siena, 1897), p. 191.

7. Gaudenz Freuler, "Manifestatori delle cose miracolose." *Arte italiana del '300 e '400 da collezioni in Svizzera e nel Liechtenstein*, exh. cat., Thyssen-Bornemisza Foundation (Lugano, 1991), pp. 69–72.

8. Federico Zeri, "Honolulu Academy of Arts: Seven Centuries of Italian Art," *Apollo* (February 1979): 88; Palladino 1997, p. 77 n. 115. Boskovits's attribution of these panels to Niccolò was taken up by Freuler (1991) who refuted, however, their association with the Costalpino altarpiece, suggesting that they may have been part of some other large complex by the artist.

9. Palladino 1997, pp. 59–60.

10. Giuseppe Merlotti, *Memorie storiche delle parrocchie suburbane della Diocesi di Siena* (Siena, 1881; Mino Marchetti, ed., Siena, 1995), p. 286. Merlotti cites a document in the Archivio di Stato, Siena (Arch. di St. Sen. Statuto dei 1288 al 1293 [*sic*], p. 24), recording that in May 1297 the Sienese Commune awarded Donna Agnese the gift of ten thousand bricks to build her hospital. I have not been able to check this reference.

11. A. Liberati, "Chiese, monasteri, oratori e spedali senesi: ricordi e notizie," *Bullettino senese di storia patria* 46 (1939): 261–64.

PROVENANCE

Santa Margherita a Costalpino, Siena; Galerie Fisher, Lucerne, November 24–28, 1953, lot 1877 (as Bartolo di Fredi); Heinz Kisters, Kreuzlingen; acquired by the Putnam Foundation, 1998.

LITERATURE

Ettore Romagnoli, *Biografia cronologica de bellartisti senesi* (Siena, 1835; reprint, Florence, 1976), 3:295–96; Gaetano Milanesi, *Documenti per la storia dell'arte senese* (Siena, 1854), 1:31–32; Giuseppe Merlotti, *Memorie storiche delle parrocchie suburbane della Diocesi di Siena* (Siena, 1881; Mino Marchetti, ed., Siena, 1995), p. 282; Miklós Boskovits, "Su Niccolò di Buonaccorso, Benedetto di Bindo, e la pittura senese del primo quattrocento," *Paragone*, nos. 359–61 (1980): 4–5, 15 n. 5; Anne Marie Doré, in *L'art gothique siennois: enluminure, peinture, orfèvrerie, sculpture* (Florence, 1983), pp. 261–62; M. Leoncini, in *La pittura in Italia: Il duecento e il trecento*, ed. E. Castelnuovo (Milan, 1986), 2:641; John Pope-Hennessy and Laurence B. Kanter, *The Robert Lehman Collection: Italian Paintings* (New York and Princeton, 1987), p. 35; Miklós Boskovits, *Gemäldegalerie, Berlin: Frühe italienische Malerei* (Berlin, 1988), p. 140; Martin Davies, *National Gallery Catalogues: The Early Italian Schools, Before 1400*, rev. Dillian Gordon (London, 1988), pp. 86, 87–88 n. 8; Cornelia Syre, *Frühe italienische Gemälde aus dem Bestand der Alten Pinakothek* (Munich, 1990), p. 45; Christie's, London, *Important and Fine Old Master Pictures*, April 23, 1993, lot 37; Anna Maria Guiducci, in *Siena, Le masse. Il terzo di Città*, ed. Roberto Guerrini (Siena, 1994), pp. 107–8; Giulietta Chelazzi Dini et al., *Pittura senese* (Milan, 1997), p. 213.

EXHIBITED

Lugano-Castagnola, Thyssen-Bornemisza Foundation, 1991, *"Manifestatori delle cose miracolose": Arte italiana del '300 e '400 da collezioni in Svizzera e nel Liechtenstein*, cat. by Gaudenz Freuler, no. 19, pp. 69–72; San Diego, Timken Museum of Art, 1997, *Art and Devotion in Siena after 1350: Luca di Tommè and Niccolò di Buonaccorso*, cat. by Pia Palladino, pl. 11, pp. 47, 57–60.

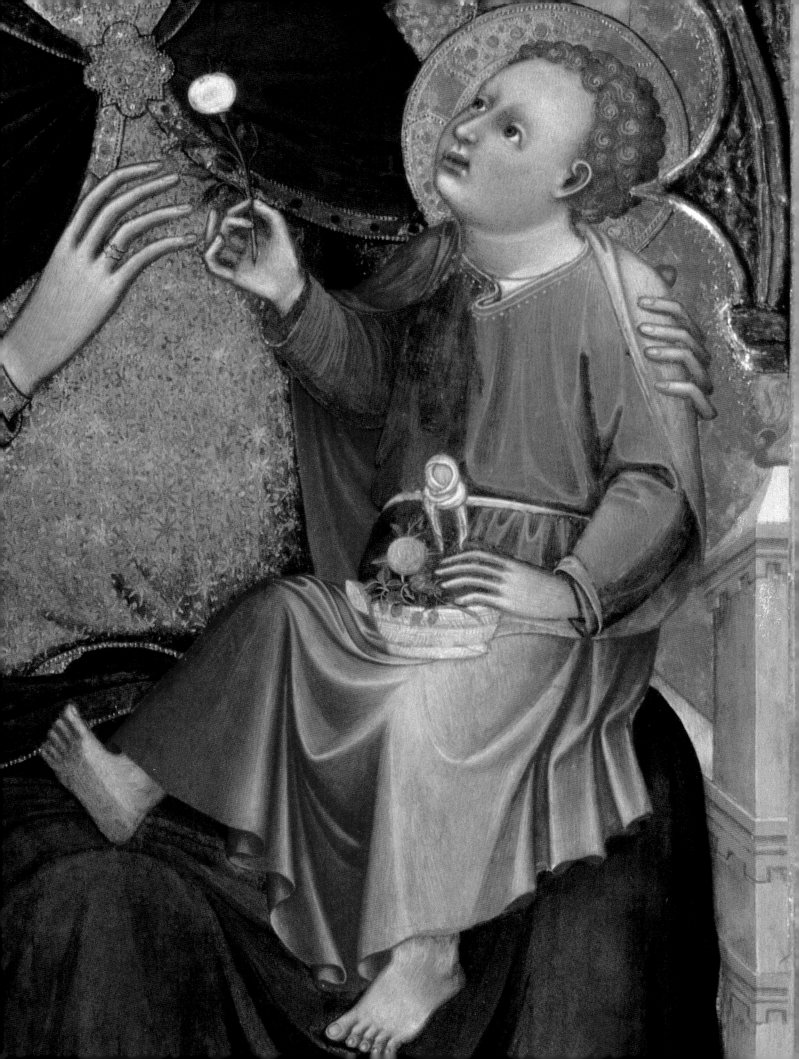

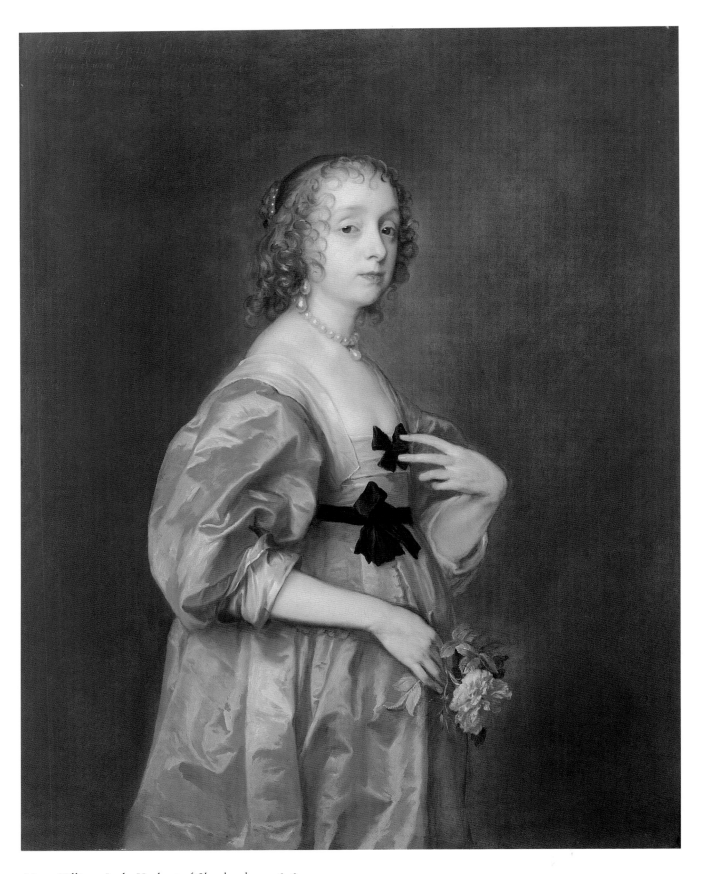

Mary Villiers, Lady Herbert of Shurland, ca. 1636

Sir Anthony van Dyck
(1599–1641)

Born in Antwerp on March 22, 1599, to Frans van Dyck, a wealthy silk merchant, and Maria Cuypers, Anthony van Dyck was apprenticed in 1609 to Hendrik van Balen (1575–1632). By 1615–16 Van Dyck appears to have established a workshop in a large house called Den Dom van Ceulen. The fact that the young artist was allowed to work independently before he joined the St. Luke's Guild in 1618 may indicate that he enjoyed the protection of Peter Paul Rubens (1577–1640). Rubens, through his contacts with the court in Brussels, was probably able to obtain special favors for Van Dyck, who was his most important assistant.

Sometime between July and November 1620, Van Dyck made his first trip to England. He apparently entered the service of King James I and also painted for the two chief patrons of the arts in Jacobean England, Thomas Howard, 2nd earl of Arundel, and George Villiers, then marquess (later 1st duke) of Buckingham. By the end of February 1621 Van Dyck returned to Antwerp for eight months before traveling to Italy. Although Van Dyck spent most of his Italian sojourn in Genoa, he also traveled to Rome, Florence, Bologna, Venice, and Palermo. While in Italy he was greatly inspired by the portraits of Titian (ca. 1488–1576), whose work he copied in a sketchbook (British Museum) and whose paintings he collected.

After his return to Antwerp in 1627, Van Dyck received many commissions for portraits and large altarpieces, including two that he painted for the Jesuit Confraternity of Bachelors in Antwerp, a lay brotherhood that he had joined in 1628. He also began an extensive project known as the *Iconography*, a series of etchings and engravings of famous princes, aristocrats, and artists that would eventually be published after his death. In 1630 the Archduchess Isabella, governess of the Spanish Netherlands, named him court painter.

In the winter of 1631–32 Van Dyck traveled to the Hague, where he worked for both the Prince of Orange, Frederik Hendrik, and for Frederick V of the Palatinate and his wife, Elizabeth Stuart, the so-called Winter King and Winter Queen. That spring Van Dyck moved to London, where, on July 5, 1632, he was knighted and named court painter for King Charles I and his wife, Queen Henrietta Maria. In 1634 Van Dyck took leave of his responsibilities at the English court and returned to Antwerp. His motivation for this decision is not known, but he possibly left for family reasons. Nevertheless, he returned to England after little more than a year, even though he had purchased a

large country estate and was made honorary dean of the Antwerp St. Luke's Guild. In the late 1630s Van Dyck and his extensive workshop continued to paint portraits and mythological paintings for the English court. On February 27, 1639, he married Mary Ruthven, a noble lady-in-waiting to the queen.

A few months after Rubens's death on May 30, 1640, Van Dyck returned once again to Antwerp, but his stay ended unsuccessfully. By May 1641 he was back in London, but he was unwell and continued working only with difficulty. Moreover, the political turmoil that had erupted in England had already unsettled the lives of many of the aristocratic patrons on whom he relied. In November Van Dyck went to Paris, but he became seriously ill and soon returned to England, where his wife gave birth to their only child, a daughter named Justiniana. Shortly thereafter, on December 9, 1641, he died. He was buried on December 11 in the choir of St. Paul's Cathedral in London, where his tomb perished in the Great Fire of 1666.

Mary Villiers, Lady Herbert of Shurland, ca. 1636

Oil on canvas, 42 × 33 in. (101 × 83.8 cm).
Inscribed at upper left: *Maria Filia Georgij Ducis Buckingamiae / relicta Spousa Philippi Herbert Primogen[iti] / Comitis Pembrociae [&/et] M[on]tgome[riae]* (Mary Daughter of George Duke of Buckingham / Widow of Philip Herbert First-born of The Earl of Pembroke [and] Montgomery). Major acquisition funding provided by Mary and Dallas Clark, Dr. Charles C. and Sue K. Edwards, Walter Fitch III Trust, Mary Ann and Arnold Ginnow, Connie K. Golden, Ingrid B. Hibben Charitable Fund, Sally S. Jones, in memory of Evan V. Jones, Jane Bowen Kirkeby, Lois Roon, in memory of Donald Roon, Donna Knox Sefton, Frances Hamilton White Donor Advised Fund at the Rancho Santa Fe Foundation, Timken Foundation, and the Friends of the Timken. Additional support provided by The Fredman Family, Karen and Robert A. Hoehn, Josephine R. MacConnell, Burl and Bill Mackenzie, Gay Michal Nay, in memory of Don L. Nay, Pamela F. and Philip R. Palisoul, J. Douglas and Marian R. Pardee Foundation, Judith and Stephen W. Smith, and Amparo Valenzuela

In this hauntingly tender portrait, Lady Mary Villiers (1622–1685), pale and delicate, and already a widow at the young age of fourteen, looks out at the viewer with the inner resolve and steadfastness of a woman who had bravely learned to make her way in an adult world. Sir Anthony van Dyck has posed this young girl against a softly brushed neutral background that sets off the smoothness and translucency of her skin, particularly evident in the gray-blue shadowed flesh tones that gently model her form. Painted with the quick rhythms of his assured brushstrokes, Lady Mary's stylish reddish brown S-curved ringlets frame her refined features, while drop pearl earrings and a pearl necklace emphasize both her physical and her moral purity. The sitter's quiet dignity is further enhanced by the gracefulness of her pose. With her left hand, in a traditional gesture of sincerity and affection, Lady Mary points to the black velvet bows on her bodice alluding to the death of her young husband, while, with the other, she holds an inverted Provence Rose in full bloom, almost certainly signifying that the life of her beloved had been snuffed out well before his time.[1]

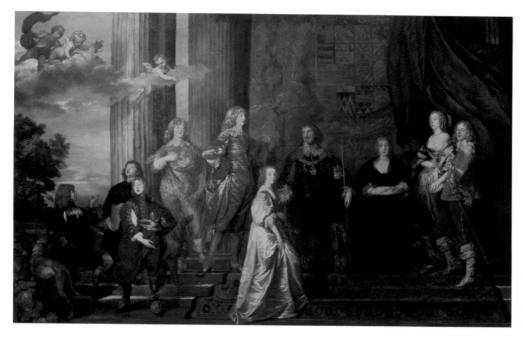

Fig 1. Anthony van Dyck, *The 4th Earl of Pembroke (Philip Herbert, 1584–1650) and His Family,* c. 1633–34 Oil on canvas, 128¾ x 199 in. (330 x 510 cm). © Collection of the Earl of Pembroke, Wilton House, Wiltshire/ Bridgeman Art Library

This recently discovered masterpiece was painted by Van Dyck apparently at the request of King Charles I, in whose collection the portrait once hung.[2] Daughter of George Villiers, duke of Buckingham, and Lady Catherine Manners, Lady Mary was one of the most intriguing individuals connected with the English court. She was raised in the royal household after Buckingham, favorite of both King James I and his son King Charles I, was assassinated in 1628. The husband she mourns was Charles, Lord Herbert of Shurland, eldest son and heir of the powerful Philip Herbert, earl of Pembroke. Be-trothed since the age of five, Lady Mary had married the fifteen-year-old Lord Herbert in King Charles I's private chapel in Whitehall in January 1635, when she was only twelve years old. Shortly after their marriage, Lord Herbert traveled to Italy to serve in the army of the Grand Duke of Tuscany, where he died of smallpox in January 1636.

Van Dyck, who was court painter for King Charles I and his wife, Queen Henrietta Maria, must have executed this portrait of Lady Mary shortly after her husband had died.[3] This excellently preserved work reveals not only how wonderfully fluid the Flem-ish master's style could be but also how sensitive he was to the psychological nuances of the female sitter. For example, while Lady Mary's shimmering gold satin dress, with its crinkly folds, suggests her inner vibrancy, the young woman's emotional fragility is made evident through the pinkish tonalities of her drooping eyelids. The intimacy of Van Dyck's portrayal is remarkable even within his own oeuvre, perhaps because of a special rapport he had with his young sitter, whom he had known since at least 1633, when he depicted her with her widowed mother.[4] In 1634 Van Dyck had featured Lady Mary in a large portrait of the family of the earl of Pembroke, who was one of his closest

patrons (fig. 1). In that painting, which is at Wilton House, the earl's future daughter-in-law, robed in white, stood near the earl and countess, a powerful visual presentation that the family's hope for the continuation of its dynastic succession rest with her.[5] The tragic circumstances that left the young Lady Mary a widow before these aspirations could be realized must have been deeply felt by the artist.

Lady Mary did not remain a widow long, for in August 1637 she married James Stuart, 4th duke of Lennox, and cousin to Charles I, a blessed event that Van Dyck anticipated in a portrayal of the young woman as St. Agnes, patron saint of those about to be married.[6] The king gave away the bride at the marriage ceremony, which was held at the Archbishop's Chapel at Lambeth Palace. James Stuart, who in 1641 was created 1st duke of Richmond, was known for his equanimity and lack of enemies, even among those opposed to Charles during the English Civil War. The duke of Richmond, who remained close to Charles throughout this period, was one of the king's pallbearers in February 1649; shortly thereafter he left England for Paris where, in 1655, he died of smallpox. In 1664 Lady Mary married yet again, this time to Colonel Thomas Howard, lieutenant of the Yeoman of the Guard. Once more, she outlived her husband, who died in 1678. When Lady Mary died in November 1685, she was buried in Westminster Abbey beside the duke of Richmond. Lady Mary had two children, Esmé Stuart, 2nd duke of Richmond, and Lady Mary Stuart, both of whom predeceased her.

Lady Mary was a prominent figure at the Stuart court, whose appearance during the 1630s Van Dyck preserved in a number of sensitive portraits.[7] She served as principal Lady of the Bedchamber to the Queen and performed in a number of court masques. A Catholic and close companion to Henrietta Maria, she accompanied the queen when she traveled to the Netherlands in 1642, and then again when the queen escaped to Paris in the mid-1640s.[8] Lady Mary remained with Henrietta Maria in France until the Restoration, but after 1661 she returned to London, where she became active in the court of Charles II. Among her literary endeavors may have been the poems written by "Ephelia," which were published in 1679 in a volume dedicated "To the most Excellent, PRINCESS MARY, Dutchess of *Richmond & Lenox.*"[9]

A.W.

12

NOTES

1. The rose, however, can have many associations with love and virtue that make a precise interpretation of its symbolic intent difficult to establish.

2. On the verso of the canvas are stamped the letters *CR* surmounted by a crown. This cipher was placed only on paintings in Charles I's personal art collection, on the authority of Abraham van der Doort, keeper of the king's pictures. This mark was discovered in 2002, when an old lining was removed during the painting's conservation. The conservation treatment was undertaken after the painting had been acquired by the art gallery Historical Portraits, London. This portrait is probably the painting referred to in Abraham van der Doort's catalogue of the collections of Charles I as "A Peece of the Dutchesse of Lenox before shee was married By Sr Anthony Vandike." See Millar 1960, 227 (Victoria and Albert manuscript, fol. 110, no. 46). Since this portrait was not in the royal collection at the time of the king's death in 1649, the probability is strong that Charles I presented it to Lady Mary, perhaps replacing it with another work by Van Dyck at the time of her marriage to James Stuart.

3. A replica of this painting is in the collection of Sir William Worsley at Hovingham Hall, Yorkshire. For this work, see Erik Larsen, *The Paintings of Anthony van Dyck*, 2 vols. (Freren 1988), 2:384, no. 978, ill.

4. For this painting (Rubenshuis, Antwerp), see Barnes 2004, pp. 449–50, no. IV.31.

5. For a discussion of this portrait, see Christopher Brown, "Van Dyck's Pembroke Family Portrait: An Inquiry into Its Italian Sources," in Arthur K. Wheelock Jr. and Susan J. Barnes, *Anthony van Dyck*, exh. cat., National Gallery of Art (Washington, D.C., 1990), pp. 37–44.

6. For this painting (Royal Collection), see Barnes 2004, pp. 590–91, no. IV.205, ill.

7. See, for example, Barnes 2004, pp. 587–91, nos. IV.203–IV.206.

8. For its insights into the English court, see Rosalind K. Marshall, *Henrietta Maria: The Intrepid Queen* (London, 1990).

9. For this argument, see *Poems by Ephelia*, ed. Maureen E. Mulvihill (Delmaar, N.Y., 1993), and an online archive, at http://www.marauder.millersville.edu/~resound/ephelia/.

PROVENANCE

King Charles I (1600–1649); possibly a gift of the king to Lady Mary Villiers (1622–1685); by inheritance to George Legge (1648–1691); 1st baron Dartmouth; William Legge (1730–1801), 2nd earl of Dartmouth, Sandwell Hall, Staffordshire; William Legge (1881–1958), 7th earl of Dartmouth, Patshull Park, Staffordshire; by descent to Lady Elizabeth Basset née Legge; Phillips, London, July 10, 2001, lot 123; Historical Portraits, London, acquired by the Putnam Foundation, 2005.

LITERATURE

Stebbing Shaw, *The History and Antiquities of Staffordshire* (London, 1801), vol. 2, pt. 1, pp. 128–32; Sir Oliver Millar, ed., "Abraham van der Doort's Catalogue of the Collections of Charles I," *Walpole Society 1958–1960* (1960): 37, 227, probably no. 46; Susan Barnes et al., *Van Dyck: A Complete Catalogue of the Paintings* (New Haven, 2004), p. 587, no. IV.203.

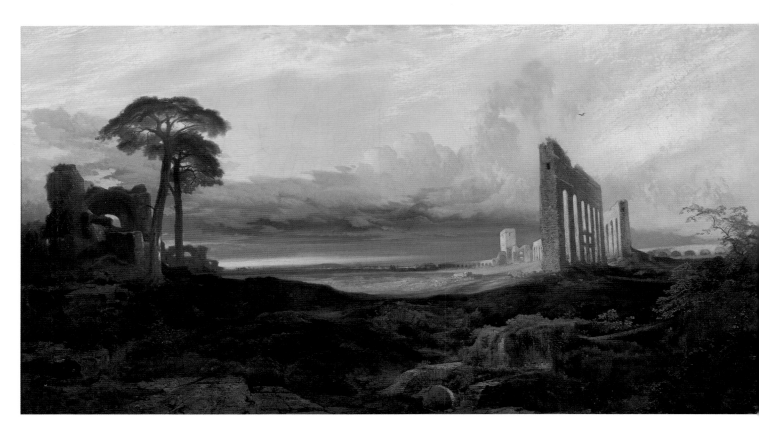

Opus 24: *Rome, from the Campagna, Sunset, 1867*

Thomas Moran
(1837–1926)

Thomas Moran was born in Bolton, England, the fifth son of Thomas and Mary Moran. To escape the bleak economic conditions brought on by the Industrial Revolution, his father, a weaver, moved the family in 1844 to Philadelphia, then a center of textile production. Thomas showed an aptitude for watercolor and drawing at an early age, and in 1853 he entered into an apprenticeship with a Philadelphia engraving firm. Two years later, he joined the art studio of his oldest brother, Edward, an aspiring artist who would earn professional success as a painter of marine scenes. By the age of twenty, Thomas was working full-time as a painter and illustrator. Although of modest financial means and education, Thomas was an avid reader and also availed himself of the cultural resources Philadelphia had to offer. Through another Philadelphia artist, James Hamilton, Thomas was introduced to the work of J. M. W. Turner, the great English landscape painter revered for his atmospheric use of light and color. Hamilton, dubbed "the American Turner," had a decisive impact on Thomas.[1] In 1862 Thomas and his brother Edward traveled to England, with the principal purpose of studying firsthand original works by Turner. A second European sojourn, in 1866–67, gave Thomas additional exposure to the work of the European masters and laid the groundwork for the paintings he would produce over the next five decades.

In 1871 the editor of *Scribner's Monthly Magazine* asked Moran to rework sketches by another artist that were to accompany an article titled "The Wonders of the Yellowstone." Moran, who had not ventured farther west than Lake Superior, saw an opportunity in the making and secured the finances to accompany a privately funded expedition to Yellowstone, which had been organized to determine the veracity of stories of hot springs and geysers. Moran's sketches were instrumental in the campaign to have Yellowstone designated a national park, and his monumental canvas of 1872, *Grand Canyon of the Yellowstone*, was the first landscape painting to be purchased by the United States government. At thirty-five, Moran had established his reputation as a painter of the American West. Over the ensuing decades Moran would travel extensively in the West, visiting Yosemite, the Teton Range, New Mexico, and Arizona, as well as Mexico. In the last years of his life, Moran divided his time between East Hampton, New York, and Santa Barbara, California, where he died in 1926.

Opus 24: *Rome, from the Campagna, Sunset,* 1867

Oil on canvas, 25 × 45⅛ in. (63.5 × 114.6 cm). Signed, dated, and inscribed lower left: *Thos Moran. 1867 / Op. 24.* Gift of Diana Woodward Stephens in memory of her father Benjamin Woodward and her husband William T. Stephens Jr.

Moran painted *Rome, from the Campagna, Sunset* in his Philadelphia studio in June 1867, one month after returning from his second trip abroad. The time spent in Europe, from June 1866 through May 1, 1867, gave Moran the opportunity to study thoroughly actual paintings of artists past and present, in order to learn their techniques. Moran made this trip in the company of his new family—his wife, Mary, whom he had married in 1863, and their young son Paul. Although Moran had already achieved some professional success—obtaining respectable prices for his pictures and exhibiting regularly at the Pennsylvania Academy of the Fine Arts—this trip was clearly conceived, like the earlier journey, as a study tour. The family began their European sojourn in Paris, where Moran established a studio and was able to take advantage of the resources available in the French capital, including the wealth of European painting assembled there for the Exposition Universelle of 1867.

Generations of northern European artists found inspiration in the landscape and art of Italy, including those to whom Moran felt a particular affinity—Nicolas Poussin, Claude Lorrain, Turner, and Camille Corot. A visit with Corot in his Paris studio may have influenced Moran to travel to Italy. Over the course of a few months the Morans journeyed from Rome to Naples, and then to the Swiss Alps.[2]

Moran produced several sketches within Rome proper, but it was his experience in the Campagna, the pastoral landscape south of the city, that would inspire a dramatic transformation in his work. In her definitive study of Moran's field sketches, the scholar Anne Morand notes a significant change in Moran's sketches of the Campagna from his earlier work. His detailed, tight compositions, evident in his forest studies from Pennsylvania and Fontainebleau (southeast of Paris), give way to a sense of panoramic space that, even in a relatively small format, yields a sense of deep space and large scale.[3]

Among the sketches he produced in February and March 1867 are several of the great Claudian Aqueduct south of Rome, including a drawing that very likely served as a preparatory sketch for the Timken picture (fig. 1).[4] In the center of the composition, a small figure on horseback makes his way up a gentle rise. To the left is a suggestion of trees and ruins. On the right, in the middle ground, is the great aqueduct, a monumental structure that gently curves into the distance, leading the viewer's eye to the cupola of St. Peter's, on the distant horizon.

Although the painting retains the basic composition of the sketch, Moran has positioned the ruins and aqueduct in a middle ground, where they stand out against a dramatic sunset replete with vibrant hues and slightly ominous cloud formations. In contrast to the drawing, the middle ground is made far more expansive, and the

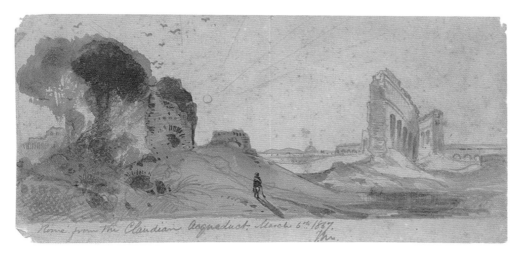

Fig. 1. *Rome from the Claudian Aqueduct*, 1867
Graphite on paper, 4 × 8 in. (10.2 × 20.3 cm). Courtesy East Hampton Library.

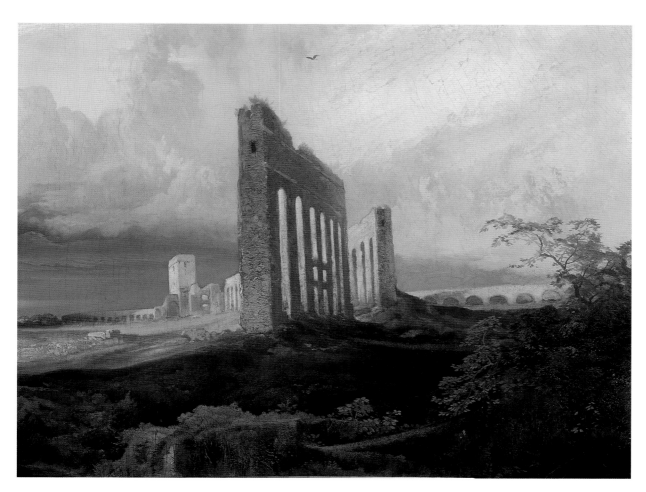

Fig 2. Detail: *Rome, from the Campagna, Sunset*

ruins and trees on the left, which form a prominent mass in the drawing, appear in the painting to be more in balance with the aqueduct. The dark foreground is dense with vegetation punctuated by brick remnants of the aqueduct. Illuminated by the setting sun, the aqueduct gently arcs into the distance, encircling an expanse of land captured in the last rays of sunlight. The ruins, on the left, are set off by two slender trees. On the distant horizon, the buildings of Rome are illuminated by the setting sun; discernible in the center, though less visible than in the drawing, is the cupola of St. Peter's.

Predating Moran's first trip to the American West by just four years, *Rome from the Campagna, Sunset* both references the lessons the artist had learned to date and anticipates what is to come. In its sense of light and atmosphere, the brilliantly colored, cloud-filled sky evokes Turner, Claude, and Corot, artists who inspired Moran. The dense, detailed foreground recalls the Pre-Raphaelite-influenced forest interiors that Moran painted in the 1860s.[5] But it is the overall conception of space that not only sets this picture apart from his earlier works but makes this painting a telling and potentially unique precursor to the open vistas and monumental expanses of the western landscapes that Moran would soon embark on.[6]

In the 1860s Moran maintained a written list of his significant works. As the artist himself wrote, "since Aug 1863 I have numbered every picture that I have painted, to which I attach any value."[7] This record, referred to as the "Opus List," includes forty-two works. The last entry dates to November 1868. *Rome, from the Campagna, Sunset* appears as number 24 on the list with additional notations.[8] Moran often inscribed the opus number near his signature; it appears on the Timken picture, just after the date.

Until recently, *Rome, from the Campagna, Sunset* was known to Moran scholars solely through the reference on the "Opus List."[9] A notation in the artist's hand, but of a later date, makes reference of the sale of the picture to a Mr. Gilbert for $75.00. The notation indicates neither date nor location, which is now thought to have taken place in the 1880s. The painting remained with Mr. Gilbert and his descendants for four generations. In 2005 it was donated to the Putnam Foundation, Timken Museum of Art, by Diana Woodward Stephens, great-granddaughter of Mr. Gilbert.

H.F.

NOTES

1. Nancy K. Anderson, *Thomas Moran*, exh. cat., National Gallery of Art (Washington, D.C., 1997), p. 24.

2. Anne Morand, *Thomas Moran: The Field Sketches, 1856–1923* (Norman, 1996), pp. 32–33.

3. See ibid. for a discussion of the transformation of Moran's sketches.

4. Nancy Anderson made the connection between Moran's drawing and the Timken picture when the existence of the painting was first brought to her attention in late 2005.

5. In her detailed discussion of Moran's influences, both visual and textual, Nancy Anderson, *Thomas Moran*, p. 25, notes that access to original works was extremely limited in Philadelphia in the 1850s, but that a large exhibition of British painting, which included works by the English Pre-Raphaelites, was shown at the Pennsylvania Academy of the Fine Arts in 1858.

6. Moran painted Italian scenes throughout his career, but Italian-themed paintings from the late 1860s, in all likelihood quite few in number, are not familiar to scholars, and for this reason the relationship between these works and the sketches and paintings of the early 1870s has not been examined in depth. This relationship is a provocative one, and it is not difficult to see in a work such as "First Sketch Made in the West at Green River, Wyoming" (Gilcrease Museum, Anderson, p. 62), Moran's Claudian Aqueduct being transformed into a butte.

7. Quoted in ibid., p. 350.

8. See ibid., p. 354. The citation, reproduced from the "Opus List" (Gilcrease Museum, Tulsa, Okla.) is as follows: "No. 24. Rome, from the Campagna, Sunset / Painted in June 1867 after return from Europe. Size 25 x 45. Shown at A.F.S. in Feb & March 1868. Sent to Chicago in April 1868. / Returned in July 1868. / [added in purple ink] Afterwards sold to Gilbert for $75.00"

9. Other than Moran's own reference on the "Opus List," no mention of the painting, or evidence of its whereabouts, was revealed in the preparation for either of the monographs cited here.

PROVENANCE

Purchased directly from the artist in the 1880s(?) by Mr. Joseph Gilbert for $75.00; presented as a wedding gift to Sylvia Gilbert, Mr. Gilbert's daughter, and Arthur Percival Woodward, early 1900s(?); by descent to their son, Benjamin Woodward; given to Diana Woodward Stephens, mid 1980s; donated by Diana Woodward Stephens to the Putnam Foundation, 2005.

LITERATURE

Nancy K. Anderson, *Thomas Moran*, exh. cat., National Gallery of Art (Washington, 1997), p. 354, "Opus List."

EXHIBITED

Philadelphia, Artists' Fund Society, February–March 1868.

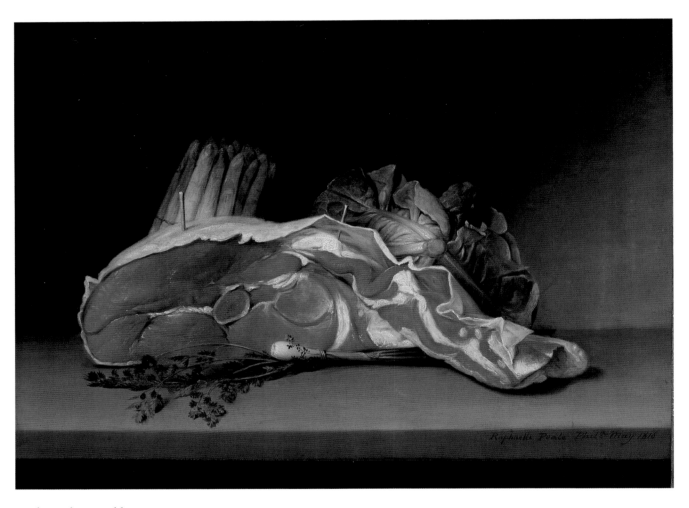

Cutlet and Vegetables, 1816

Raphaelle Peale
(1774–1825)

Raphaelle was the eldest and most gifted of the many children of Charles Willson Peale.[1] The elder Peale—artistic polymath, patriot, inventor, and museum founder—harbored high artistic ambitions for his children. The very names he gave them bespeak this: Raphaelle, followed by Angelica Kauffman (b. 1775), Rembrandt (b. 1778), Titian Ramsey I (b. 1780), Rubens (b. 1784), and Sophonisba Angusciola (b. 1786).[2] The paternal expectation was to some degree fulfilled, as the extended Peale family was a force in artistic Philadelphia through the nineteenth century. But the expectation apparently weighed heavily on the eldest son, who was outshone in his lifetime by the portrait and history painting career of his brother Rembrandt. Rather than following the more prestigious fields chosen by Rembrandt, Raphaelle Peale assisted in the museums in Philadelphia and Baltimore founded by his family, cut silhouettes (and painted a few portraits, largely as an itinerant throughout the young nation), patented a process against the depradations of sea worms, wrote doggerel for a baker's treats, and focused on the painting of still lifes.[3] He showed these last in 1795 at the first public art exhibition in the United States—the one exhibition of the short-lived Columbianum (an art academy founded by the elder Peale[4])—and then annually from 1812 to 1824 at the Pennsylvania Academy of the Fine Arts.

Peale's mature life was a stormy and unhappy one. He married against his father's wishes; financial support of his large family was a continual challenge. His father and family apparently purchased the majority of his still-life pictures (although a number of important American patrons, too, added the inexpensive panels to their collections) and helped support him in various ways.[5] But by 1809 he reportedly suffered from alcoholism, was threatened by his wife with divorce, and was committed for delirium at the Pennsylvania Hospital. To these difficulties was added the incapacitation of gout.[6] He died, impoverished and reportedly in great pain, at the relatively early age of fifty-one.

Cutlet and Vegetables, 1816

Oil on panel, 18¼ x 24¼ in. (46.4 x 61.5 cm). Signed, dated, and inscribed lower right: *Raphaelle Peale Phila May 1816*. Dated on verso in pencil: *1816*. Acquisition made possible through contributions from the Fredman Family and the Friends of the Timken.

The majority of Peale's known still lifes show food and utensils related to its preparation and service, rather than such other traditional still-life elements as flowers, dead game, or inanimate luxury items (books, sculpture, money, textiles, musical instruments, and the like).[7] The vast percentage of these, in turn, show fruits: peaches, apples, melons, grapes and raisins, and berries of various kinds (nuts and various citrus fruits, too, appear). The occasional baked goods and appropriate porcelain, glass, and silver objects often accompany the fruit, all of which evoke a mood of postprandial relaxation, even if there is no attempt to re-create an actual dessert setting or practice. The effect is of luxury, elegance, and sweetness.[8] Then there are a few extant works that complicate the gustatory expectations of the viewer: what is a stalk of celery doing amid apples and raisins?[9] Or a partially peeled ear of corn next to a sliced melon?[10] Or red and green peppers beside grapes, apples, and another split melon (the apples and melon having passed beyond ripeness toward rottenness)?[11]

But the works that most stand out among Peale's food still lifes are those featuring savories: *Cheese and Three Crackers* (1813, private collection); *Still Life with Dried Fish [A Herring]* (1815, Historical Society of Pennsylvania); and, most disturbing of all, two paintings that feature large chunks of raw meat—*Still Life with Steak*, ca. 1817 (fig. 1), and the Timken's *Cutlet and Vegetables* of 1816. These last two, as the scholar William Gerdts points out, fall into the tradition of "kitchen pictures," with antecedent examples by such artists as the eighteenth-century Frenchman Jean-Siméon Chardin—although no examples of Chardin's work in this mode are known to have been in America in the early nineteenth century.[12] Even earlier painters—the sixteenth-century Amsterdam artists Pieter Aertsen and Joachim Beuckelaer—had used the glistening wares of meat stalls and butcher shops as the foregrounds of religious works to further the contrast between fleshly and spiritual concerns. Both had also made meat still lifes without apparent moralistic overtones, focusing solely on virtuosic reproduction that was in turn imitated by painters throughout Europe.[13] But how or if Peale was aware of these carnivore-subject precedents is unknown. Likewise, although Dr. John Foulke, an amateur and one of the organizers of the Columbianum, in 1795 showed a painting called *Ribs of Raw Beef* that Peale must have seen, we do not now know the work and cannot judge what, if any, impact it might have had on the young professional. Nor do we have any evidence of the visual culture of Philadelphia in the form of painted shop signs depicting raw meat that Peale might have had in his mind's eye as he composed his two meat compositions of 1816 and 1817. From what we know, Peale's efforts in this subject matter were unlike anything he had the opportunity to see in another's art.

The Timken's painting is the largest of Peale's known still-life panels.[14] The impressive scale of the work, taken in conjunction with the full inscription at lower right of signature, city, month, and year (unusual although not unprecedented in its detail), signals that Peale attached a particular importance to it. And *attach* is in fact an apt word, since some of the panel's height has been gained by the addition of a second piece of wood (approximately one by twenty-four inches) to the bottom of the large

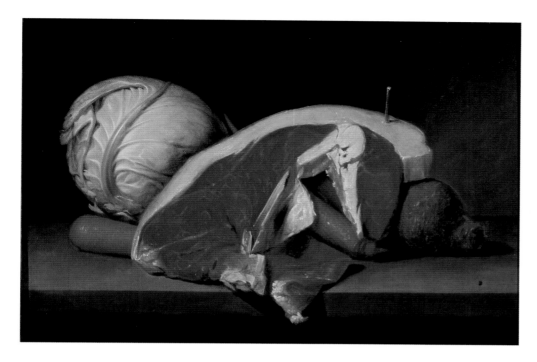

Fig. 1. Raphaelle Peale, *Still Life with Steak*, ca. 1817
Oil on wood, 13⅜ x 19½ in.
(34 × 49.5 cm)
Munson-Williams-Proctor Arts
Institute, Museum of Art, Utica,
New York, 53.215

panel. This attachment, which seems original, adds another distinction to it. Almost all of Peale's still lifes show objects sitting on a neutrally colored counter or tabletop. A few depict only the horizontal surface with things resting on it.[15] But the vast majority of the scenes include the front edge of the tabletop; this flat surface, the fictional edge of the table that is parallel to the real picture plane, imposes itself between the scene and the viewer—it increases the sense of display, and it is there, to the right, that Peale invariably signs his name. In a very few instances (I know of only four), however, Peale gave not only the front of the table edge but its bottom contour and the empty space beneath. This is simply a band of darkness—it does nothing to suggest the room or the character of the table/counter. But it does impose a greater emotional distance between the spectator and the things portrayed. Both of the still lifes with raw meat have this extra band at the bottom.[16] In the case of the Timken painting, that band and the additional strip of wood coincide. Since the Timken's is apparently the earliest of the four, it was probably the first where Peale felt the need to add space to the bottom of the composition—to the extent of adding to the panel.

Perhaps this desire arose because of the subject and the intensity of its presentation. *Cutlet and Vegetables* can be a profoundly unsettling picture. Peale's close attention to the reality of the meat—its wet and glistening pink surface pierced by wooden pins that hold the white butcher's paper in place atop the muscle; the equally white, glabrous registers of fat larded throughout—gives it a presence far greater than that accorded the bunch of asparagus in the background, or even the cheery lettuce, scallion, rosemary, and chervil that surround the roseate flesh. That presence arises in part from an identification

of the portrayed meat with the flesh of our own bodies. But there is a more intense feeling than the queasiness that some vegetarians report on seeing quantities of raw meat, which seems to develop from the sense that Peale has, in some uncanny fashion, animated the cutlet by paying too close and indecorous an attention to it.[17]

Peale and his family evidently thought well of the picture. On March 4, 1817, in an advertisement for the Peale Museum in Philadelphia, *Poulson's American Daily Advertiser* announced that "numerous valuable and interesting subjects" had been added to the display, including "A Still Life Piece, representing a fillet of Veal and Vegetables.—Painted by Mr. Raphael Peale."[18] The picture apparently stayed with the Peale Museum until the auction sale of the collection in 1854, when it was purchased by Townsend Ward, librarian of the Historical Society of Pennsylvania, for $20—the highest price given for any of Peale's still lifes then on offer.[19]

Raphaelle Peale received encouragement and admonishment from his father in near equal doses throughout his life. Just a year and a half after he completed *Cutlet and Vegetables*, he received a letter from Charles Willson Peale that encapsulates the relation of the two men:

> I well know your talents, and am fully confident that if you applied [yourself] as you ought to do, you would be the first painter in America. . . . Your pictures of still-life are acknowledged to be, even by the Painters here, far exceeding all other works of that kind—and you have often heard me say that I thought with such talents of exact immitation your portraits ought also to be more excellent—My dear Raph. then why will you neglect yourself—? Why not govern every unruly Passion? why not act the *man*, and with a firm determination act according to your best judgement? Wealth, honors and happiness would then be your lot![20]

Cutlet and Vegetables, one of Raphaelle's most ambitious and singular panels, testifies to the achievement of this gifted man, for whom wealth, honors, and happiness remained sadly out of reach.

M.S.

NOTES

1. Raphaelle was the fifth-born child but the first to survive infancy. For a detailed and documentary biography of Raphaelle Peale's full career, see Lillian B. Miller, "Father and Son: The Relationship of Charles Willson Peale and Raphaelle Peale," *American Art Journal* 25 (1993): 4–63. The standard text for Peale's still lifes is Nicolai Cikovsky Jr. et al., *Raphaelle Peale Still Lifes*, exh. cat., National Gallery of Art (Washington, D.C., 1988). See also David C. Ward and Sidney Hart, "Subversion and Illusion in the Life and Art of Raphaelle Peale," *American Art* 8, nos. 3–4 (Summer/Fall 1994): 96–121; Brandon Brame Fortune, "A Delicate Balance: Raphaelle Peale's Still-Life Paintings and the Ideal of Temperance," in *The Peale Family: Creation of a Legacy, 1770–1870*, ed. Lillian Miller, exh. cat. (New York, 1996), pp. 135–49; and Alexander Nemerov, *The Body of Raphaelle Peale: Still Life and Selfhood, 1812–1824* (Berkeley, 2001).

2. These are the children of Peale's first marriage. Those of the second added such science-oriented names as Linnaeus and Benjamin Franklin to the mix, augmented by Vandyke (b. 1792), Sybilla Miriam (b. 1797), Titian Ramsay II (b. 1799).

3. Rembrandt Peale wrote to the earliest historian of American art, William Dunlap: "Raphael was a painter of portraits in oil and miniature, but excelled more in compositions of still life. He may perhaps be considered the first in point of time who adopted this branch of painting in America" (quoted in Dunlap, *A History of the Rise and Progress of the Arts of Design in the United States*, 3 vols. [1834; Boston, 1918], 2:181).

4. Raphaelle showed five portraits and eight still lifes (Cikovsky, *Raphaelle Peale Still Lifes*, p. 119). He was also—in effigy—on display there, portrayed as the young man climbing the staircase in his father's *The Staircase Group* (1795, Philadelphia Museum of Art).

5. "My Father & my Brother separately on their own accounts have from the beginning of my Labours in this line [painting still life] engaged to take all the Pictures I can Paint" (Raphaelle Peale to Charles Graff, September 6, 1816, Archives of American Art, Misc. MSS; quoted in Cikovsky, *Raphaelle Peale Still Lifes*, p. 104).

6. He wrote in 1816 to his patron Charles Graff: "My old and inveterate enemy, the Gout, has Commenced a most violent attack on me, two months previous to its regular time—and most unfortunately on the day that I was to Commence still life, in the most beautifull productions of Fruit, I therefore fear that the Season will pass without producing a single Picture. . . . [I]f the disease was only confined to my feet I still would have some hope of doing something. But unfortunately my left hand is in a most dreadfull situation, & my Right Getting so bad as to be scarcely able to hold my Pen—" (September 6, 1816, Archives of American Art, Misc. MSS; quoted with variants in Cikovsky, *Raphaelle Peale Still Lifes*, p. 103).

Phoebe Lloyd has argued that many of Peale's ailments were brought on by extended exposure to the poisons necessary for the taxidermy connected with the family museums ("Philadelphia Story," *Art in America* 76 [November 1988]: 155–71, 195–203). Miller argues against this explanation of his illnesses in "Father and Son: The Relationship of Charles Willson Peale and Raphaelle Peale." She concludes that his physical problems derived from his alcoholism, perhaps complicated by "saturnine gout" brought on by lead poisoning, transferred from lead-lined or lead-joined stills by the fortified spirits he drank in excess.

7. The exceptions are noteworthy. Foremost among them is his one known "deception"—a painting meant to fool the eye: *Venus Rising from the Sea—A Deception* (1822, Nelson-Atkins Museum of Art, Kansas City, Mo.), with a lovingly and convincingly detailed napkin "covering" a depiction of a nude. He is also recorded as painting exhibition catalogues that would hang in place and fool visitors who would reach for the catalogue as a guide to the show (Cikovsky, *Raphaelle Peale Still Lifes*, p. 48).

8. These paintings can range in apparent complexity from a single peach or stem of blackberries on a plate (*Still Life with Peach* [ca. 1816, San Diego Museum of Art] or *Blackberries* [ca. 1813, Fine Arts Museums of San Francisco]) to such elaborate confections as *Still Life with Wild Strawberries* (1822, Art Institute of Chicago), with covered glass vessel, porcelain creamer and sugar bowl, saucers, service plates, and a variety of foodstuffs.

9. *Still Life with Celery and Wine* (1816, Munson-Williams-Proctor Arts Institute, Museum of Art).

10. *Corn and Cantaloupe* (ca. 1813, private collection).

11. *Fruit and Silver Bowl* (1814, Manoogian Collection).

12. William H. Gerdts, entry on *Cutlet and Vegetables* in Robert Devlin Schwartz, *150 Years of Philadelphia Still-Life Painting*, exh. cat., Schwarz Gallery (Philadelphia, 1997), pp. 20–23. See also Gerdts's entry on *Still Life with Steak* in *Masterworks of American Art from the Munson-Williams-Proctor Institute*, ed. Paul D. Schweizer (New York, 1989), pp. 24–25, 219. Gerdts first published the documentation on these works and set parameters of our understanding of their history.

13. For a terse encapsulation, see William B. Jordan, *Spanish Still Life in the Golden Age: 1600–1650*, exh. cat., Kimbell Art Museum (Fort Worth, Tex., 1985), pp. 3–5.

14. Several works on canvas are marginally larger: *Still Life with Watermelon* (1822, Museum of Fine Arts, Springfield, Mass., 24½ x 29½ in.) and *Melons and Morning Glories* (1813, Smithsonian American Art Museum, 20¾ x 25¾ in.).

15. *Blackberries* (ca. 1813, Fine Arts Museums of San Francisco), *Corn and Cantaloupe* (ca. 1813, private collection), and *Lemons and Sugar* (ca. 1822, Reading Public Museum and Art Gallery, Reading, Pa.).

16. As do *Still Life with Wine Glass* (1818, Detroit Institute of Arts) and the highly unusual *Strawberries and Cream* (1818, Mr. and Mrs. Paul Mellon Collection), which portrays a marble rather than simple wooden tabletop. Of the four, the latter is the only one signed in a bright color in the empty space rather than on the table's edge.

17. Nemerov has written of this phenomenological response in elaborate and culturally rich detail in *The Body of Raphaelle Peale*, esp. chaps. 5–7. His writings present a challenging and immensely engaged reading of the works, from which I have obviously benefited.

18. Quoted in Nemerov, *The Body of Raphaelle Peale*, p. 89. The cut of meat portrayed—even the animal it comes from—has prompted disagreement. William Woys Weaver, a historical food researcher, wrote in 1995 that Peale has shown "an old Philadelphia cut of bacon not now familiar to us because it includes the fore-end with forehock and a piece of the flitch" (letter to David Cassedy, Schwarz Gallery, January 13, 1995; quoted in Nemerov, *The Body of Raphaelle Peale*, p. 83). But the meat is called veal in the *Poulson's* advertisement in 1817; in what is said to be a manuscript page of additions to the Peale Museum catalogue in Charles Willson Peale's hand, where the work is titled "231. A loin of Veal" (*Historical Catalogue of Paintings in the Philadelphia Museum* [1813, with later handwritten additions; Historical Society of Philadelphia]); and in an annotated copy of the 1854 sales catalogue, where it is called *Loin of Veal* (M. Thomas and Sons, Auctioneers, *Peale's Museum Gallery of Oil Paintings, National Portrait and Historical Gallery Illustrative of American History*, October 6, 1854, lot 257 [copy in the Historical Society of Philadelphia]).

19. Gerdts, entry on *Cutlet and Vegetables*, p. 22.

20. Charles Willson Peale to Raphaelle Peale, November 15, 1817; quoted in Cikovsky, *Raphaelle Peale Still Lifes*, p. 104.

PROVENANCE

Peale Museum, Philadelphia, by 1817; M. Thomas & Sons, Auctioneers, Philadelphia *(Peale's Museum Gallery of Oil Paintings, National Portrait and Historical Gallery Illustrative of American History)*, October 6, 1854, lot 257 (as *Cutlet and Vegetables*); Townsend Ward, Philadelphia, 1854; private collections; Skinner, Inc., Boston, November 11, 1994, lot 69 (as *Still Life—Beef and Cabbage*); Schwarz Galleries, Philadelphia, 1994; acquired by the Putnam Foundation, 2000.

LITERATURE

Poulson's American Daily Advertiser (Philadelphia), March 4, 1817; Alexander Nemerov, *The Body of Raphaelle Peale: Still Life and Selfhood, 1812–1824* (Berkeley, 2001), pp. 83–140.

EXHIBITED

Philadelphia, Peale Museum, March 1817 and later; Cincinnati, Ohio, Peale Museum Collection, 1852; Washington, D.C., Corcoran Gallery of Art, 1997, *The Peale Family: Creation of a Legacy, 1770–1870*, not in cat.; Philadelphia, Schwarz Gallery, 1997, *150 Years of Philadelphia Still-Life Painting*, cat. by Robert Devlin Schwarz, entry by William H. Gerdts, pp. 20–23, ill.

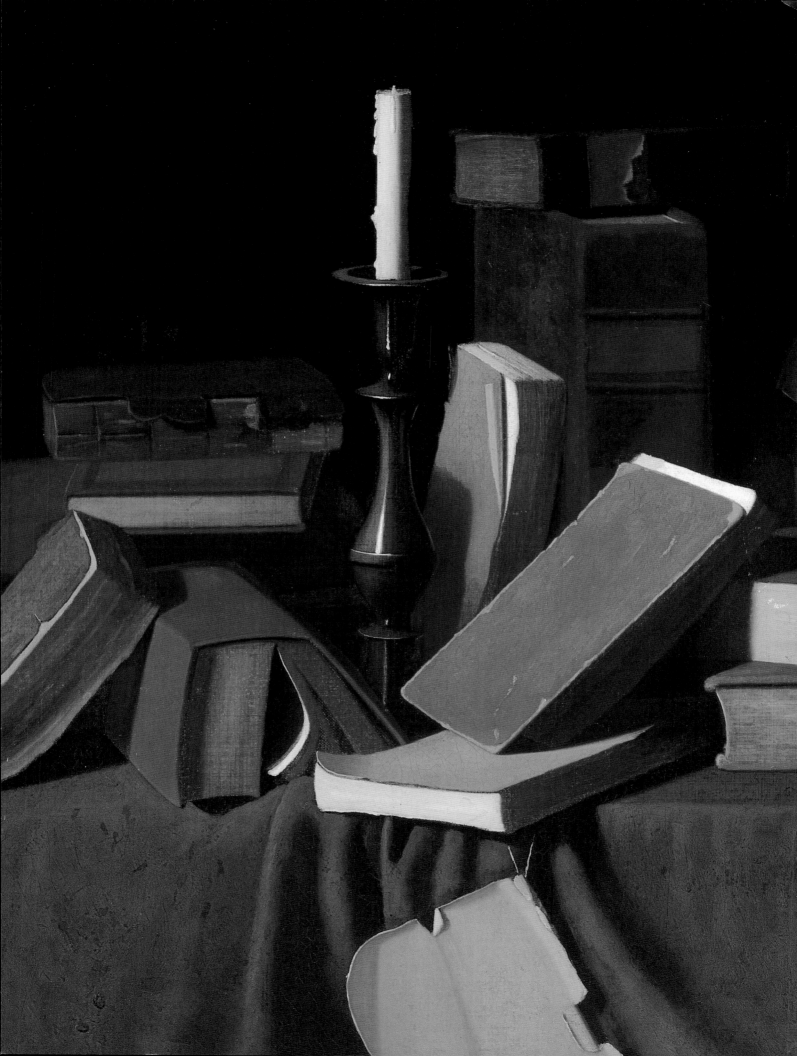

In the Library, 1894/1900

John Frederick Peto
(1854–1907)

John Frederick Peto was born in Philadelphia. His father, in the 1860s, was a gilder and dealer there in picture frames (although the painter-to-be lived as a child and young man not with him but with his maternal grandmother and aunts). He listed himself as an artist in the Philadelphia directory of 1876 and the next year enrolled in the Pennsylvania Academy of the Fine Arts, where, as student and professional, he exhibited sporadically through 1887. He experimented with various media, including framing and gilding, architecture, monumental sculpture, and especially photography, but he made the painting of still life his principal focus—one shared by his friend and colleague William Michael Harnett. In 1887, while on a professional visit to Cincinnati, he met and married a woman fifteen years his junior. In 1889 the couple moved to Island Heights, New Jersey, where, along with his painting, Peto opened a photographic studio and played cornet for Methodist camp meetings. (Music was central in his life; in photographs he often holds a cornet or violin.) Devoting considerable attention to these varied activities, his family, legal matters concerning the estate of a great-aunt, and his own ill health, Peto slid from the view of the wider art world after 1890. He died of the effects of kidney disease and high blood pressure in 1907.[1]

In the Library, 1894/1900

Oil on canvas, 30 x 40 in. (76.2 x 101.6 cm). Signed and dated lower right: *J. F. Peto/1900*. Signed, dated, and inscribed on verso: IN THE LIBRARY./John F. Peto/ARTIST./1894/ISLAND HEIGHTS/N.J. Acquisition made possible through contributions from Sally S. Jones, the Legler Benbough Foundation, J. Douglas and Marian R. Pardee Foundation, J. W. Sefton Foundation, and the Friends of the Timken.

By the 1940s, when American art of the nineteenth century began to attract commercial and scholarly attention, several of Peto's paintings had been altered to bear the name of his more famous colleague, Harnett. With the intense efforts of the journalist-curator Alfred Frankenstein to sort out the work of America's trompe l'oeil (or "fool-the-eye") painters, Peto after 1949 came to be classed as a follower of Harnett.[2] The scholar John Wilmerding, starting with an exhibition at the National Gallery of Art in 1983, developed a framework that set Peto's art apart from Harnett's, as a sensibility engaged by different questions and priorities, and of a comparable if not greater aesthetic achievement.[3]

Peto painted books for nearly his whole career, from at least 1880 until his death.[4] They seem to have been important both in his life and as a particularly rich source of inspiration for him: many photographs of his studio show open volumes lying about; he had a library of his own in his Island Heights home; and he painted trompe l'oeil shelves filled with books in that house. That is, in the real world he seems to have appreciated books for their utilitarian as well as their decorative qualities. Within his many pictures of them, books appear as one among several items of casual and solitary masculine pleasure; as items for sale; or as things stored, together with lamps and inkwells, on a shelf.[5] They are everyday tools rather than precious incunabula or collectibles. Moreover, he never paints the books with such precision as to give a specific, titled identity to them. Instead, their slightly softened forms radiate an aura that ranges from well-used familiarity (the title of one of Peto's last paintings, *Old Companions*,[6] well articulates the feeling) to worn-out neglect.

Among the most resonant and mysterious of Peto's late paintings are a handful of large-scale pictures, sometimes called library paintings, showing books—with the occasional salt-glaze mug, ink pot, candlestick, or pipe—gathered on a table covered with a dark cloth. *Still Life with Pitcher, Candle, and Books* (fig. 1) exemplifies the type; the large-scale *Books on a Table* (fig. 2) was at one time thought to show this type at its most grandiose. Then, in 2000, the painting now in the Timken came to light. Signed and, more unusually, doubly dated by the artist, *In the Library* had apparently descended in a Philadelphia family for four generations, unknown to scholars.

These late paintings of library tables have much in common. The books themselves, characteristically portrayed without titles or authors, seem to have been heavily used. Someone has piled them up irresponsibly: covers hang by a thread; bindings are strained. And yet, in spite of the presence of candlesticks (and, in some pictures, tankard, inkwell, and quill pen), there is no place at the table to write, nor are there sheets of paper with recently penned notes, nor is there evidence of the kind of work these resources have been mustered to help carry out. Through use, overuse, and misuse, the books—tokens of learning and civilization—now approach a state of dissolution. Time—both the passage of an extended period that ages the bindings of the books and a suspended moment of the present that waits for a thread to snap—enters the painting through the imagery. Scholars, Wilmerding preeminent among them, have written of the melancholic resolution that attends these pictures of battered books: "despite the superficial disorder and injury to his books, [there is] a calming sense of respite."[7]

In part Peto evokes this calm through the dark tones and rich colors of the volumes and the tablecloths on which they sit. The books' gently modulated colors—bindings, spines, or edges depicted as simple geometric forms—are arrayed in a horizontal band across the center of the canvas, sandwiched by darkness.[8] Thus, in purely formal terms, the composition seems dynamically balanced, although the narrative depicted implies the motion of gravity pulling on the precarious piles. This tension between image and effect is part of the pictures' strengths. There is also an air of quiet in these

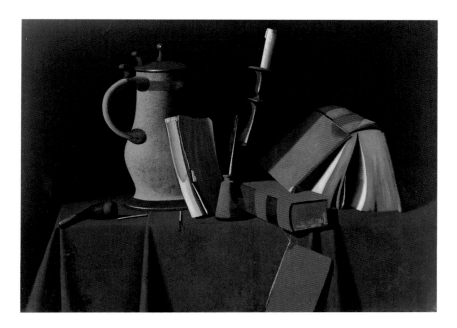

Fig. 1. John Frederick Peto, *Still Life with Pitcher, Candle, and Books*, ca. 1900 Oil on canvas, 22¼ x 30¼ in. (56.5 x 76.8 cm.). Fine Arts Museums of San Francisco, Museum purchase, gift of the M.H. de Young Museum Society and the Patrons of Art and Music, 72.32

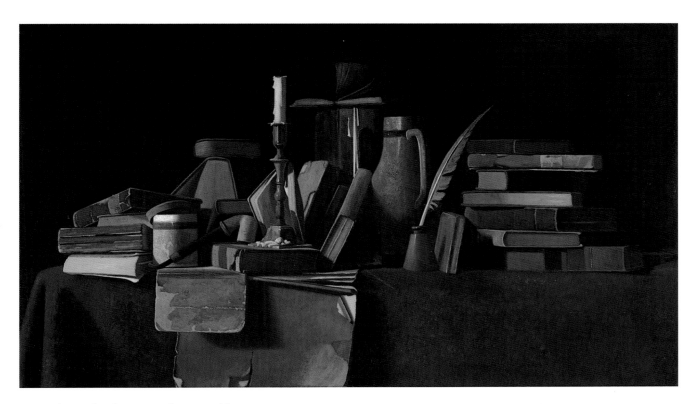

Fig 2. John Frederick Peto, *Books on a Table*, 1900 Oil on canvas, 24½ x 42⅞ in. (62.23 x 108.89 cm.), The Nelson-Atkins Museum of Art, Kansas City, Missouri. Purchase: Nelson Trust through the exchange of a gift of the Friends of Art, 90-11. Photograph by Jamison Miller

library works that complements the visual order: they conjure few sounds, as a result of Peto's choice to keep the background in a darkness that reads as encompassing shadow. And just as there is no sound in these paintings, there is also an exceedingly limited appeal to touch, a traditional complement of much still-life painting. Peto's restrained brushwork is neither invisible and contributory to trompe l'oeil effect, nor is it a bravura factor in the paintings' presentations. The one place in the library paintings where he consistently suggests texture is in the tablecloths, where irregular coruscations reveal a mottled surface to viewers.[9] This does not suggest the feel of textile, however, so much as it registers difference from the smooth paint application of the books and things on top of the cloth—making the viewer aware of the nontactile nature of Peto's treatment of these objects that might, in reality, generally be handled.

Several significant differences set the Timken painting apart from its mates. At thirty by forty inches, it is among the largest of Peto's paintings. (It is apparently the largest of the tabletop still lifes; only a few of the trompe l'oeil doors are larger.) Peto has used the extra canvas not to paint the individual objects at a greater scale but to increase the vertical expanse of space above and cloth below the things on the tabletop. This lends the picture an even greater calm, a more reflective distance between viewer and object, than is present in many of Peto's works. We seem, now, not so readily able to reach out and grasp a volume or touch the gathered cloth. Peto augments this sense of distance by elevating the point of view, allowing us ever so slightly to look down on the scene—note that he shows the full top of the candlestick's bobeche, an elevation unlike any other of the library tabletops. Taken together, these choices lend the Timken painting a grandeur that distinguishes it from all his other work.

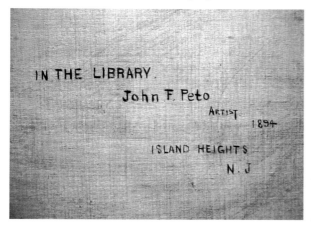

Fig. 3. *In the Library*, reverse with artist's inscription.

The inscription on the back, too, with its three deliberately differentiated fonts, sets the Timken painting apart (fig. 3). Its emphatic title—in all capital letters—leaves no doubt that Peto set the scene in "the library," presumably his own. His dating of the picture on the back to 1894, and on the front to 1900, could signal that he worked on it over the extended period, although the assurance of the composition would seem to indicate that he did not labor over it. More likely, the signature and later date on the front commemorate the work's sale or gift. Especially poignant is the inscription's declaration that Peto is an "Artist," as if the master who could achieve the picture still had to assert that status through the word as well as the act of painting. All these factors, in concert with the high quality of the picture itself, signal its special status within the painter's oeuvre.

M.S.

NOTES

1. The two principal sources for Peto remain Alfred Frankenstein, *After the Hunt: William Harnett and Other American Still Life Painters, 1870–1900*, rev. ed. (Berkeley, 1969), pp. 3–24, 99–111; and John Wilmerding, *Important Information Inside: The Art of John F. Peto and the Idea of Still-Life Painting in Nineteenth-Century America*, exh. cat., National Gallery of Art (Washington, D.C., 1983).

2. The story is told, from a variety of perspectives, in Frankenstein, *After the Hunt*, pp. 3–24; Wilmerding, *Important Information Inside*, pp. 25–29; Olive Bragazzi, "The Story behind the Rediscovery of William Harnett and John Peto by Edith Halpert and Alfred Frankenstein," *American Art Journal* 16, no. 2 (Spring 1984): 51–65; and Elizabeth Johns, "Harnett Enters Art History," in Doreen Bolger, Marc Simpson, and John Wilmerding, *William M. Harnett*, exh. cat., Amon Carter Museum and Metropolitan Museum of Art (New York, 1992), pp. 100–112.

3. Wilmerding, *Important Information Inside*, passim.

4. As, for example, in *Violin, Fan and Books*, 1880, which was with David David, Inc., Philadelphia, as of 1983.

5. As in *Tobacco Canister, Book and Pipe* (1888, Meredith Long & Co., Houston, as of 1983) or *The Writer's Table: A Precarious Moment* (ca. 1890s, Manoogian Collection); one of his few Pennsylvania Academy of the Fine Arts exhibition pictures—*Take Your Choice* (1885, John Wilmerding Collection) or *Job Lot Cheap* (1892, Fine Arts Museums of San Francisco); and in *Still Life with Lard Oil Lamp* (1900s, Newark Museum), respectively.

6. 1904, Jo Ann and Julian Ganz Collection.

7. Wilmerding, *Important Information Inside*, p. 136.

8. The calm, geometric compositions and lack of overt narratives in his pictures helped foster an enthusiasm for Peto's works among leading advocates of modernism in the 1930s and 1940s even before his name was known. Alfred Barr, first director of New York's Museum of Modern Art, for instance, owned three paintings by him that had been sold as by Harnett (see Johns, "Harnett Enters Art History," p. 111 n. 39).

9. Peto also will add this effect—achieved by adding irregular thick daubs to the underlayers of paint—to the salt-glaze mugs on his tabletops and the brightest highlights of supposedly metallic objects.

PROVENANCE

Private collection, Philadelphia, reportedly by family descent for four generations, ca. 1900–1999 [documented from ca. 1931 as with Harriet Edkins; to her daughter Helen Edkins Campbell, 1973; to J. Stewart Campbell, her husband, 1977; to James S. Campbell and Harriet R. Campbell Young, their children, 1999]; Kennedy Galleries, New York, 1999; acquired by the Putnam Foundation, 2000.

LITERATURE

American Masters from Copley to Hopper (New York: Kennedy Galleries, 1999), no. 7, ill. (detail ill. on front cover); Kelly Devine Thomas, "Collecting in Cyberspace," *Artnews* 99, no. 1 (January 2000): 133.

EXHIBITED

New York, Kennedy Galleries, 1999–2000, *American Masters from Copley to Hopper*, no. 7.

Index

ARTISTS IN THE PUTNAM FOUNDATION COLLECTION